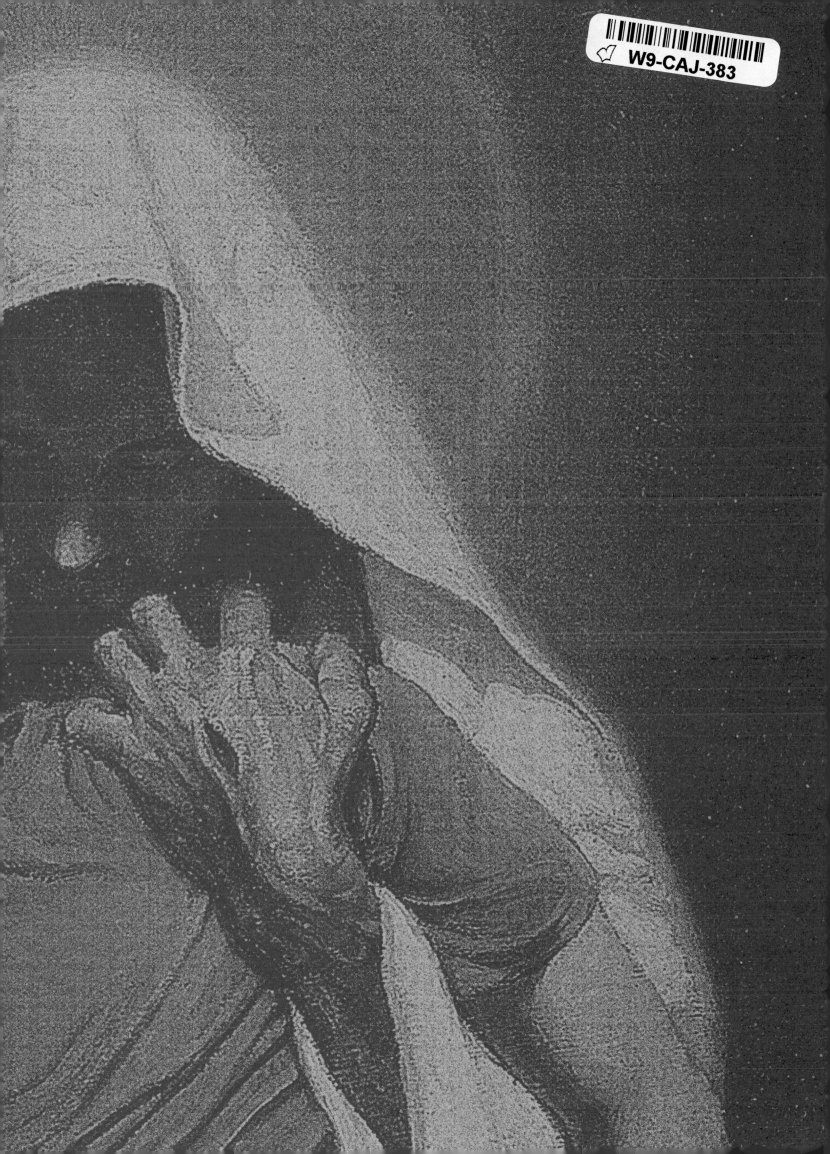

FORGIVEN

Col 1:13-14

ABOUT THE PAINTING

Forgiven is the first painting by Thomas Blackshear II
for *The MasterPeace Collection*.

Thomas states, "For a long time I have wanted to do a painting that
would minister to God's people. I began to seek God for an image.
I asked Him to give me an idea that would speak to His people. After a
number of weeks of prayer and fasting, God answered and an image
was given. *Forgiven* is the answer to that prayer."

Forgiven portrays one of the most important truths—no matter what sins
may have been made in life, God has made the way for forgiveness and
restored fellowship through the atoning sacrifice of His Son, Jesus. The
print features a contemporary man in a pose of despair, ready to fall to
the ground. In one hand he has a mallet and in the other a large spike.
These are symbols of the truth that each of us is responsible for Christ's
death on the cross. Holding up this broken modern man is Jesus Christ.
The entire scene takes place on Mt. Calvary, the place where His blood
was shed. On the ground lilies grow—a powerful reminder that out of
death has come new life, the resurrection life of Jesus Christ.

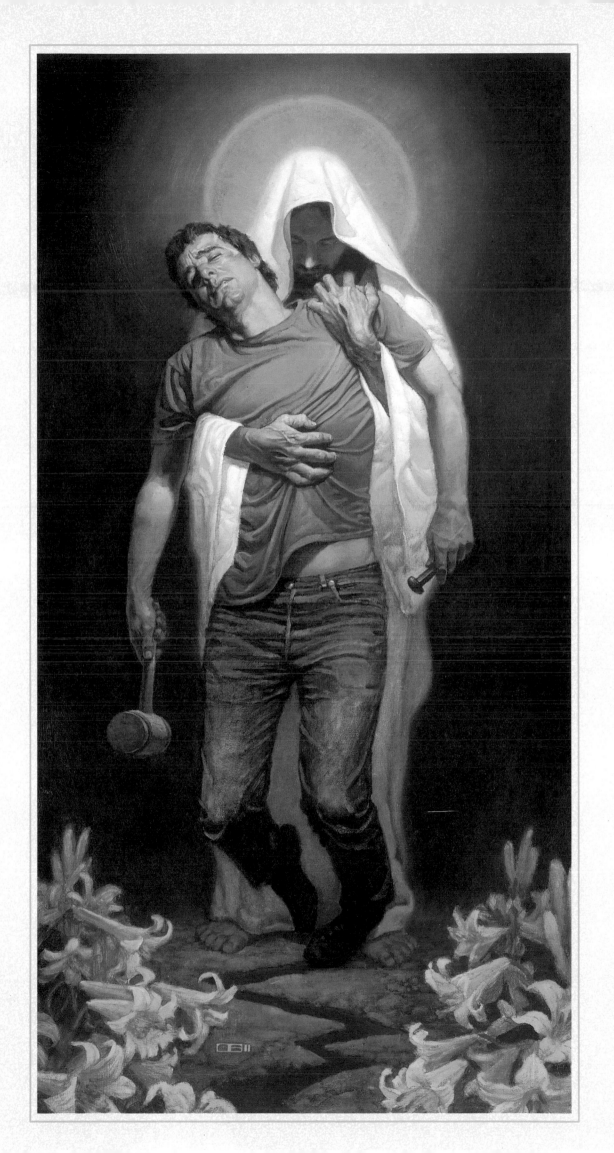

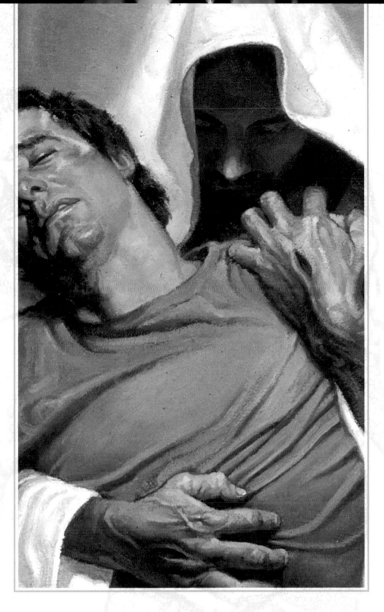

\mathcal{F}ORGIVEN

the Painting by THOMAS BLACKSHEAR II

Heart Reflections
Written by ROY LESSIN

THE MasterPeace COLLECTION

A Division of DaySpring Cards

Dedicated to every heart that
seeks the joy of being forgiven.

Other devotional books
by ROY LESSIN:

Never Forgotten...Always Loved!
Within His Hands...Without a Fear!
Knowing His Best...Walking in Rest!
Receiving His Blessing...Giving His Love!

Other MasterPeace paintings
by THOMAS BLACKSHEAR II:

Watchers in the Night
Coat of Many Colors, Lord of All

FORGIVEN

the Painting by Thomas Blackshear II
Heart Reflections written by Roy Lessin

© 1996 by *The MasterPeace Collection,*®
a division of DaySpring Cards.
All Scriptures taken from the
New American Standard Bible ® ©
The Lockman Foundation 1962, 1963,
1968, 1971, 1972, 1973, 1975, 1977
Used with permission.

Art Direction: Todd Knowlton, Paul Higdon

Book Design: Koechel Peterson & Associates

Printed In Hong Kong

ISBN 1-884009-07-7

CONTENTS

֍ DARKNESS 11

The painting's dark background signifies sin. It is the world
of darkness within us that the light of Jesus Christ seeks to invade.

֍ GUILT 15

The mallet and the spike in the man's hands are reminders that
each of us is responsible for the death of Jesus Christ on the cross.

֍ REPENTANCE 19

The contemporary man in the painting is in despair and ready
to fall to the ground. His expression carries the pain of sin, and his
helplessness reflects total dependence on Jesus Christ for his salvation.

֍ GRACE 23

The figure upholding the repentant man is a picture of God's grace. He is the ever-present
Jesus, ready to receive and redeem all who have been broken by the power of sin.

֍ REDEMPTION 27

The setting of Forgiven is Mt. Calvary, the place where Jesus was crucified. It is here
that He died to redeem us to God. It is here that each sinner must come to be forgiven.

֍ STRENGTH 31

Jesus' hands are slightly oversized, showing strength. They remind us that
we cannot rely on our own strength; we are totally dependent upon the Lord.

֍ HOLINESS 35

The halo of light around Jesus' head signifies His holiness and divinity.

֍ CHANGE 39

The wounded hand of Jesus over the man's heart upholds him
and reveals God's desire to change all hearts by the power of His love.

֍ RIGHTEOUSNESS 43

The white robe that Jesus is wearing speaks to us of His righteousness.
It is the garment with which we must all be clothed.

֍ JUSTIFICATION 47

The blood that flows from Jesus' feet signifies the washing
away of our sin and our justification before God.

֍ WORSHIP 51

The lilies in Forgiven remind us of the Lord's beauty and our worship
and adoration of Him, the Lily of the Valley and the Rose of Sharon.

֍ GROWTH 55

The lilies also represent our personal growth in the Lord. Because
He is alive in us, His life will produce fruit for His glory.

A WORD FROM THE AUTHOR

The painting *Forgiven* reveals the heart of God toward me. As I look at the scene, I not only see Jesus wrapping His arms around a fallen man, but I also see Him wrapping His arms of mercy around me. My eyes tell me Jesus is holding a broken sinner, but my heart tells me that Jesus is holding me.

As I look, wonder, and ponder this painting, there is one message that speaks the loudest to my heart—it is the overwhelming truth that Jesus loves me as no one else ever could. His suffering, His sacrifice, His death, were all for me. When I look at the cross I never need to question if He loves me. He came for me, He died for me, He lives for me. When I look at His shed blood, I never need to question my worth. I am worth to God the death of His Son. A tremendous price has been paid—more than all the riches of all the kingdoms in all the world.

Roy Lessin

ABOUT THIS BOOK

The devotional book *Forgiven* is designed to take you step by step through 12 key visual symbols within Thomas Blackshear II's painting. Each chapter contains one aspect of the painting, a topical selection of Bible verses, a heart reflection based upon the truth revealed in both the painting and the verses, and a prayer.

For clarity, the Scripture selections in each chapter have been arranged in a single paragraph format. The Scripture references are listed in the order of their appearance at the bottom of the paragraph.

This book is written with a prayer that the truth of God will be known in your heart as you reflect on all Jesus has done for you. As you read through the pages and meditate upon the painting, may it bless you and bring you the joy of being forgiven!

DARKNESS

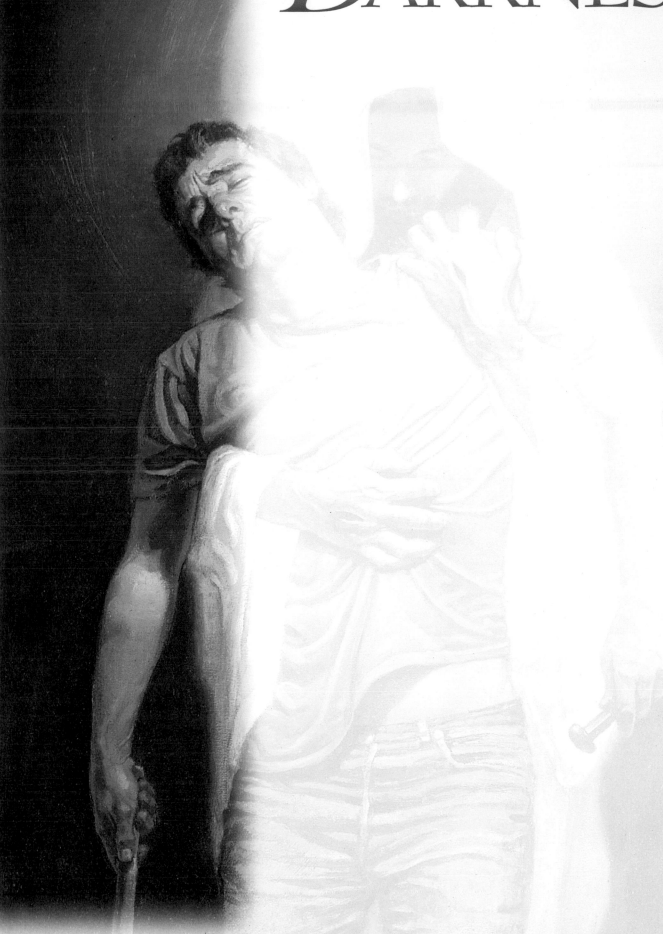

*T*his is the message we have heard from Him and announce to you, that God

is light, and in Him there is no darkness at all. For God, who said, 'Light

shall shine out of darkness,' is the One who has shone in our hearts

to give the light of the knowledge of the glory of God in the face of

Christ. 'To open their eyes so that they may turn from darkness to

light and from the dominion of Satan to God, in order that they may

receive forgiveness of sins and an inheritance among those who have

been sanctified by faith in Me.' 'Because of the tender mercy of our

God, with which the Sunrise from on high shall visit us, TO SHINE

UPON THOSE WHO SIT IN DARKNESS AND THE SHADOW OF

DEATH, to guide our feet into the way of peace.'

I John 1:5 ~ II Corinthians 4:6 ~ Acts 26:18 ~ Luke 1:78, 79

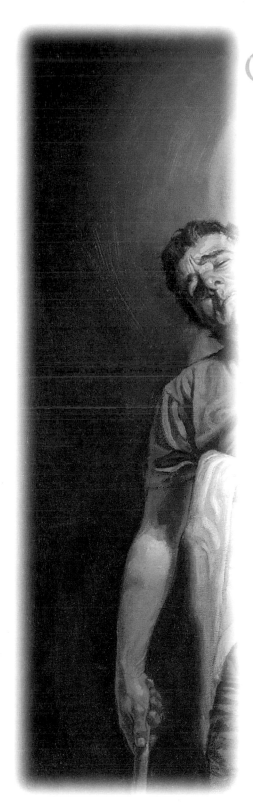

The painting's dark background signifies sin. It is the world of darkness within us that the light of Jesus Christ seeks to invade.

Spiritual darkness is the absence of God's truth in our hearts and lives. We can have an education and still be in darkness. We can study philosophy and religion and still be in darkness. We can go to church or do social work in our community and still live in darkness. We can be sincere or be tolerant of others and what they believe and still be in darkness.

Darkness is unbelief. Darkness is deception, keeping us from the knowledge of God. Darkness is separation, keeping us from the fellowship of God. Darkness is isolation, keeping us from the presence of God. Darkness is something we should treat as an enemy, yet when we are in sin, we treat it as a friend. We like darkness (it hides us from being exposed for who we really are). The sin in us runs deep, and the darkness is our cloak.

Although we may be hiding from Him, He is not hiding from us. Jesus seeks us out in our darkness. He is standing near us, clothed with white garments...covered with glory...reaching out with arms of mercy...inviting us into the marvelous light of His forgiveness and love.

LORD,

*D*eliver me from the darkness of my own way. Place Your truth within me so I may know You and Your ways. I want to come out of my hiding and walk with You in Your light. I know that nothing is hidden from You; You know me inside and out. I release every lie and deception that has kept me from You. Thank You that You can take me from the kingdom of darkness and place me into the kingdom of light. I welcome Your light and love into my life. ॐ

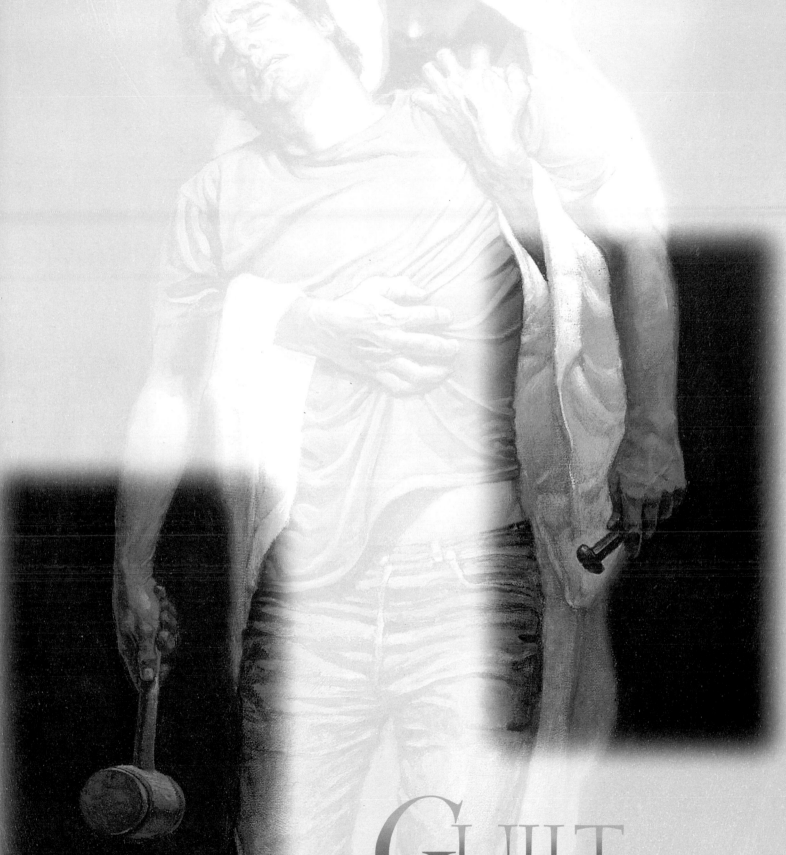

GUILT

s it is written, 'THERE IS NONE RIGHTEOUS, NOT EVEN ONE.'

But He was pierced through for our transgressions, He was crushed

for our iniquities; the chastening for our well-being fell upon Him, and

by His scourging we are healed. But God demonstrates His own love

toward us, in that while we were yet sinners, Christ died for us. For all

have sinned and fall short of the glory of God. That, as sin reigned in

death, even so grace might reign through righteousness to eternal life

through Jesus Christ our Lord.

Romans 3:10 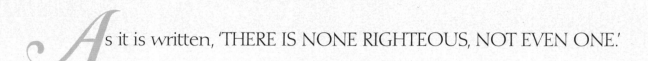 *Isaiah 53:5* *Romans 5:8* *Romans 3:23* *Romans 5:21*

The mallet and the spike in the man's hands are reminders that each of us is responsible for the death of Jesus Christ on the cross.

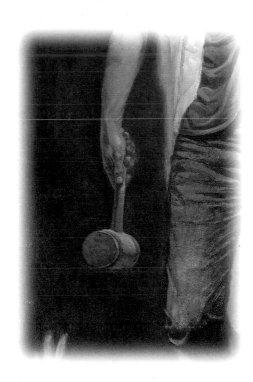

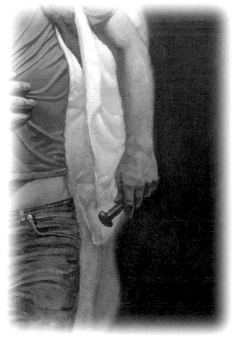

*I*t was the darkness and rebellion of our sin that sent Jesus Christ from heaven to earth on a mission of redemption. He came as light into the darkness, but those in the darkness were not able to understand it. He came even though we didn't know how desperately we needed Him. He came to pay the debt we owed but couldn't pay. He came as a physician who didn't wait for office calls but lived among us to seek and save those who were being destroyed by the plague of sin. He didn't die as a martyr or a reformer; He died as the spotless, sacrificial lamb, willing to make atonement for our sin.

The mallet and the spikes were in our hands while goodness and mercy were in His...rebellion and deceit were in our character, grace and truth were in His...hardness and coldness were in our hearts, tenderness and compassion in His. Jesus was the perfect offering for our imperfections—taking our judgment, bearing our sorrow, tasting our death, triumphing over our hell, and seeking to take us captive with the awesome power of resurrection life. ✌

LORD,

I know my sin sent You to the cross. I thank You that You didn't just die for the world; You died for me. I know I am the guilty one. Everything I deserve was placed on You. I come to You without excuse, knowing I am fully responsible for my own sin. Thank You that through Your wounds I have found mercy and by them I can be healed. ॐ

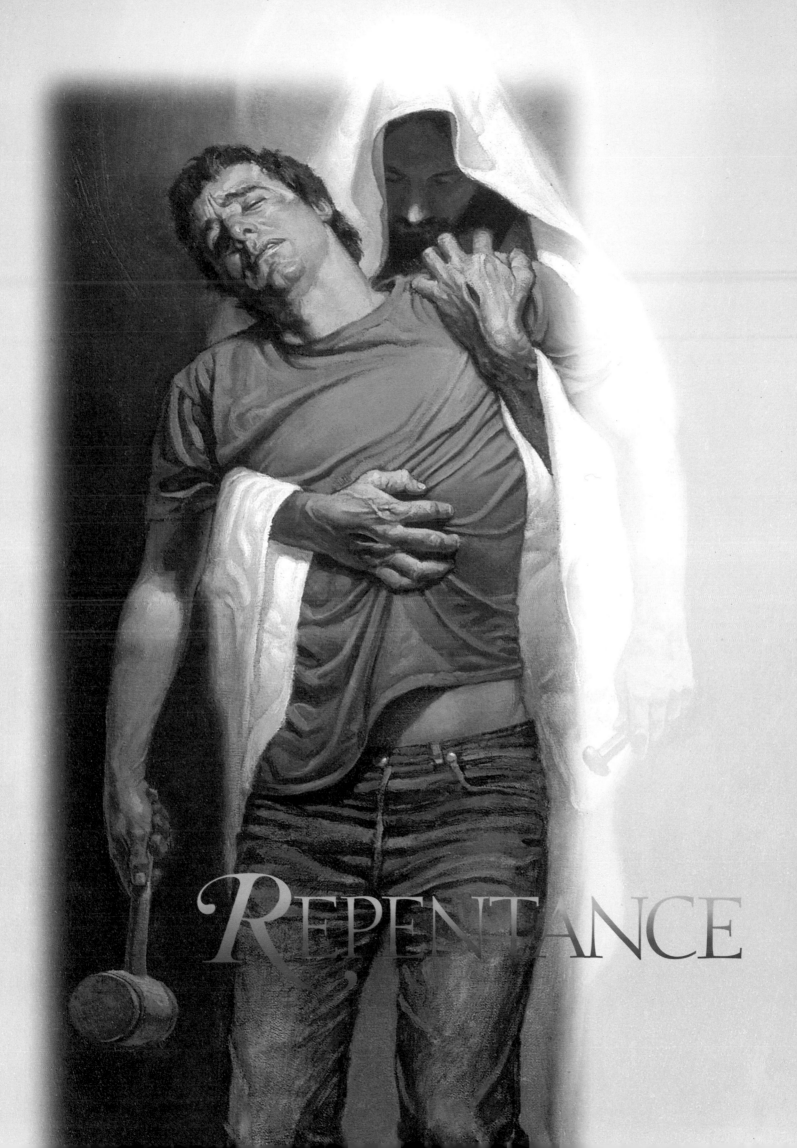

REPENTANCE

*H*e [John] came into all the district around the Jordan, preaching a baptism of repentance for the forgiveness of sins. Solemnly testifying to both Jews and Greeks of repentance toward God and faith in our Lord Jesus Christ. But the tax-gatherer, standing some distance away, was even unwilling to lift up his eyes to heaven, but was beating his breast, saying, 'God, be merciful to me, the sinner!' But go and learn what this means, 'I DESIRE COMPASSION, AND NOT SACRIFICE,' for I did not come to call the righteous, but sinners. And hearing this, Jesus said to them, 'It is not those who are healthy who need a physician, but those who are sick; I did not come to call the righteous, but sinners.' 'I tell you that in the same way, there will be more joy in heaven over one sinner who repents, than over ninety-nine righteous persons who need no repentance.'

Luke 3:3 ↬ Acts 20:21 ↬ Luke 18:13 ↬ Matthew 9:13 ↬ Mark 2:17 ↬ Luke 15:7

The contemporary man in the painting is in despair and ready to fall to the ground. His expression carries the pain of sin, and his helplessness reflects total dependence on Jesus Christ for his salvation.

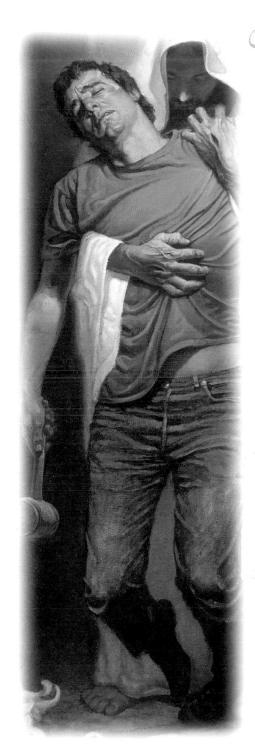

When we come out of our darkness into the light of Jesus Christ, we become broken by our sins. The light shows us that we are not whole but shattered...not worthy but guilty...not rich but bankrupt...not confident but desperate...not mighty but lowly...not holy but unclean. The light leaves us totally exposed—we see ourselves as God sees us, and the revelation breaks our hearts and shatters our pride. We don't seek to be patched or fixed up but to be made new. We realize we have no covering to hide in...no offering to hope in...no works to glory in. We are undone. We are sinners.

Our sorrow for our sins may bring remorse, but our repentance is more than remorse; our sorrow for our sins may lead us to restitution, but our repentance is more than restitution; our sorrow for our sins may create a desire to make resolutions, but repentance is more than resolutions.

Repentance means being sorry enough for our sin to stop; convicted enough by our sin to turn from it; broken enough by our sin to be willing to change. It is our repentance that turns us toward the Light. It is our need of Him that draws us to the light. It is our faith in Him that clothes us in the light. Our only covering is His righteousness...our only hope is His mercy...our only glory is the light of His holy love. ᔇ

LORD,

At the heart of my sin is the desire to have my own way. I choose to turn from my way to Your way...from my plans to Your purposes...from my independence to Your Lordship. I am sorry for the ways I have hurt You. As I turn to You, I hope in Your mercy, Your truth, and Your love. I place my life in Your hands for You to make me into the person You have created me to be. ❧

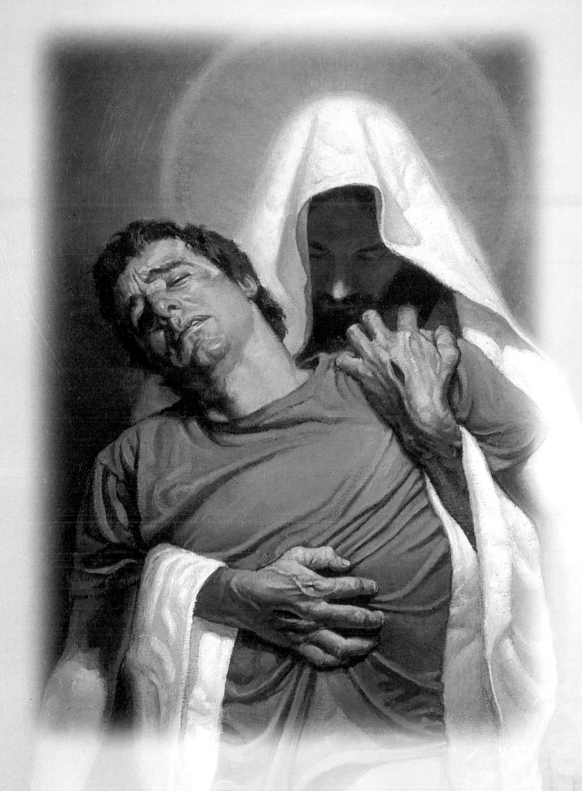

GRACE

THE SPIRIT OF THE LORD IS UPON ME, BECAUSE HE ANOINTED ME TO PREACH THE GOSPEL TO THE POOR. HE HAS SENT ME TO PROCLAIM RELEASE TO THE CAPTIVES, AND RECOVERY OF SIGHT TO THE BLIND, TO SET FREE THOSE WHO ARE DOWNTRODDEN. But He gives a greater grace. Therefore it says, 'GOD IS OPPOSED TO THE PROUD, BUT GIVES GRACE TO THE HUMBLE.' But as for you, speak the things which are fitting for sound doctrine. In Him we have redemption through His blood, the forgiveness of our trespasses, according to the riches of His grace. For by grace you have been saved through faith; and that not of yourselves, it is the gift of God.

Luke 4:18 ∾ James 4:6 ∾ Titus 2:1 ∾ Ephesians 1:7 ∾ Ephesians 2:8

The figure upholding the repentant man is a picture of God's grace. He is the ever-present Jesus, ready to receive and redeem all who have been broken by the power of sin.

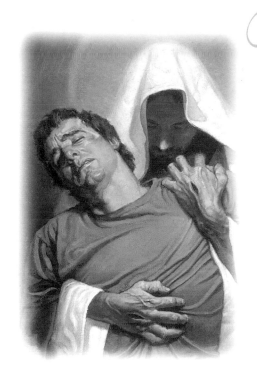

The beauty of the Gospel is what we discover when, broken by sin, we turn from the darkness of our own way to the light of Jesus Christ. We don't find a God of indifference who cares nothing about us but a God of compassion and tender mercy. We don't find a God who is distant or unable to reach us because of His holiness but a God who has totally identified Himself with our needs. We don't find a God of wrath who must be appeased but a God who extends His grace and forgiveness to us freely.

Grace is the kindness and favor of God extended to you. It is nothing you can earn or deserve. Grace is God saying to you, "You can do nothing to save yourself; there is no need to even try because I have done it all. I have given My Son to die for you, and He has made the perfect sacrifice for your sin. Come and receive My free gift."

In grace there is no debt, no works, no bondage, no striving, no weight, no burden. Grace is favor and acceptance. Grace is the absolute bounty of God poured generously upon you with the oil to heal your wounds...the power to renew your strength...the goodness to restore your soul...the love to make all things new. Grace is the outstretched arms of God embracing you in His love.

LORD,

I marvel at Your grace. There is
nothing I have done for You, yet
You have done everything for me.
I come to You broken, knowing You
can make me whole...I come to You
empty, knowing You can make me
full...I come to You bound, knowing
You can set me free. I come as a child
in simplicity and faith to receive Your
free gift of grace. Pour Your generosity
upon me and make me whole.

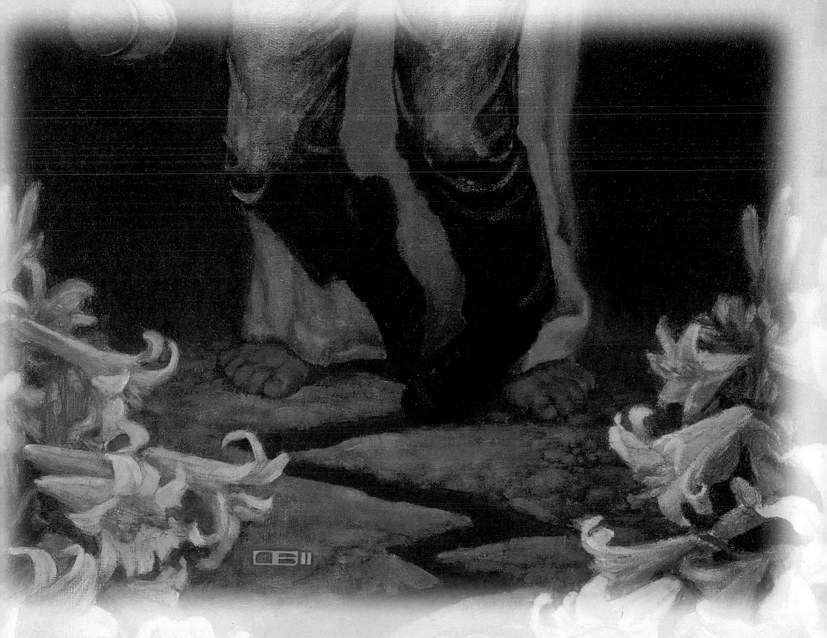

REDEMPTION

*B*lessed be the Lord God of Israel, for He has visited us and accomplished

redemption for His people. Who gave Himself for us, that He might

redeem us from every lawless deed and purify for Himself a people

for His own possession, zealous for good deeds. Knowing that you

were not redeemed with perishable things like silver or gold from your

futile way of life inherited from your forefathers, but with precious

blood, as of a lamb unblemished and spotless, the blood of Christ.

Being justified as a gift by His grace through the redemption which is

in Christ Jesus. But by His doing you are in Christ Jesus, who became

to us wisdom from God, and righteousness and sanctification, and

redemption. In Him we have redemption through His blood, the

forgiveness of our trespasses, according to the riches of His grace.

Luke 1:68 ✦ Titus 2:14 ✦ I Peter 1:18, 19 ✦ Romans 3:24 ✦ I Corinthians 1:30 ✦ Ephesians 1:7

The setting of Forgiven is Mt. Calvary, the place where Jesus was crucified. It is here that He died to redeem us to God. It is here that each sinner must come to be forgiven.

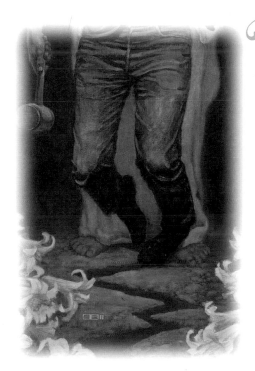

We needed a redeemer—someone who would buy us back from the captivity of sin and Satan over our lives. Jesus Christ is the only one who could pay the ransom that would free us from Satan's hold. There was only one price that could be paid to deliver us—the shed blood of Jesus Christ on the cross.

A young boy once made a beautiful toy sailboat out of wood. When he finished creating the boat, he took it to a nearby lake to sail. The boy was thrilled with his creation and proudly placed it in the water. The boat was all the boy had hoped it would be. All was well until a strong gust of wind blew the boat out of the boy's reach and out into the lake. In just a few minutes the boat was lost. Several weeks later when the boy passed a toy store, he noticed a sailboat in the window. Upon closer examination, the boy discovered it was his boat. "That's my boat in your window," the boy said to the store owner, "and I'd like it back."

"I'm sorry," said the store owner, "but I own the boat now. If you want it, you'll have to buy it." When the boy found out the price for the boat, he went home and sold all he had to buy the boat back. After returning to the store with the full payment, the boy took the boat to his heart and said, "Little boat, you are twice mine now. I made you and I bought you."

And because of our redemption we are twice the Lord's—He made us and He bought us back with His blood. ᔓ

LORD,

I am not my own; You have bought me with the price of Your own blood. I want to glorify You. Thank You that I am Your property and that Satan has no claim on me. I rejoice in the freedom I have in Jesus Christ. How blessed I am! You love me so much that You gave all You had to buy me back from the slavery of sin.

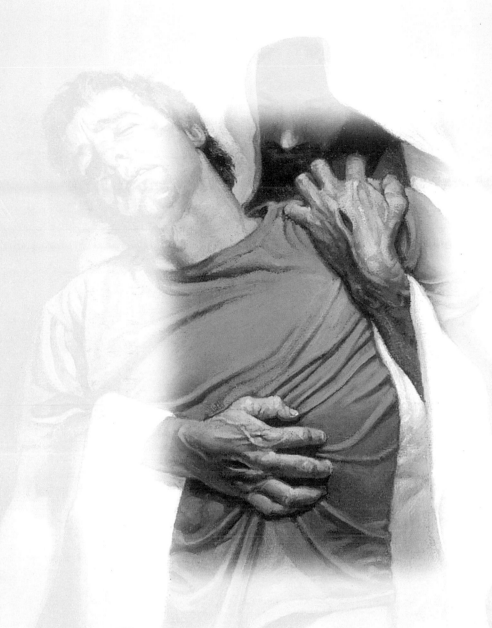

STRENGTH

Cast your burden upon the Lord, and He will sustain you; He will never

allow the righteous to be shaken. My flesh and my heart may fail,

but God is the strength of my heart and my portion forever. On God

my salvation and my glory rest. The rock of my strength, my refuge is

in God. The Lord will give strength to His people; the Lord will bless

His people with peace. 'Your locks shall be iron and bronze, and

according to your days, so shall your leisurely walk be.' 'Do not fear, for

I am with you; do not anxiously look about you, for I am your God.

I will strengthen you, surely I will help you, surely I will uphold you

with My righteous right hand.' Now to Him who is able to keep you

from stumbling, and to make you stand in the presence of His glory

blameless with great joy.

Psalm 55:22 ✖ Psalm 73:26 ✖ Psalm 62:7 ✖ Psalm 29:11 ✖ Deuteronomy 33:25 ✖ Isaiah 41:10 ✖ Jude 24

*Jesus' hands are slightly oversized, showing strength.
They remind us that we cannot rely on our own strength;
we are totally dependent upon the Lord.*

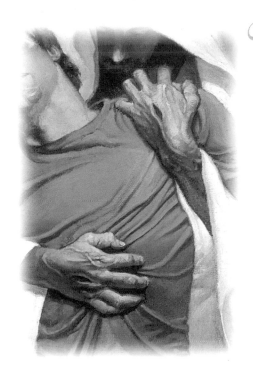

We cannot, in our own strength, live the life God wants us to live. It is not only difficult, it is impossible. Salvation is of the Lord. We cannot save ourselves or keep ourselves from the power of sin. He is the one who lifts us out of the pit of despair and sets our feet on the rock of Jesus Christ.

The life God has for us is an exchanged life— we exchange our own way for His perfect will... our selfish plans for His holy purpose...our soiled garments for His robes of righteousness...we exchange our weakness for His strength...our fear for His power...our emptiness for His fullness.

It is when we become poor in spirit that we can become rich toward God. Because His arms are around us, we can be assured that He will never leave us or release His hold upon our lives. What would be considered impossible for us becomes possible with God—we cannot, but He can; we have not, but He possesses all things. We can do all things through Christ who strengthens us. ◦

LORD,

I know if there is anything good that comes from my life it will be You doing it in and through me. I thank You that You have the power to save me and to keep me close to You. I believe You have me in Your hands and will keep me close to Your heart. You are my hope, my fortress, and my strength. ⌇

HOLINESS

For we do not have a high priest who cannot sympathize with our weaknesses, but one who has been tempted in all things as we are, yet without sin. I will bow down toward Thy holy temple, and give thanks to Thy name for Thy lovingkindness and Thy truth. For Thou hast magnified Thy word according to all Thy name. O sing to the Lord a new song, for He has done wonderful things. His right hand and His holy arm have gained the victory for Him. O send out Thy light and Thy truth, let them lead me. Let them bring me to Thy holy hill, and to Thy dwelling places. But as for me, by Thine abundant lovingkindness I will enter Thy house, at Thy holy temple I will bow in reverence for Thee. Just as He chose us in Him before the foundation of the world, that we should be holy and blameless before Him. Ascribe to the Lord the glory due to His name; worship the Lord in holy array.

Hebrews 4:15 ❧ Psalm 138:2 ❧ Psalm 98:1 ❧ Psalm 43:3 ❧ Psalm 5:7 ❧ Ephesians 1:4 ❧ Psalm 29:2

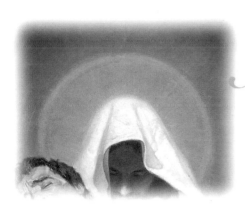

The halo of light around Jesus' head signifies His holiness and divinity.

Jesus Christ is more than a prophet, a teacher, or a good man. As the God-man, He was tempted in all points as we are, but He was without sin. He is God incarnate; Immanuel, God with us; the Word become flesh; the only begotten of the Father that we might become the righteousness of God in Him. One of the great miracles of God is that He forms His life within us. Only He can take an unholy person out of the world, cleanse and forgive that person, place that person back into the world, and empower that person to live a holy life.

Holiness is to our spirits what good health is to our bodies. Holiness is healthiness. It is the song within us that declares, "It is well with my soul." Holiness is beauty. It is the beauty of God's character seen in the face of Jesus Christ. Holiness is love. It is the cup of the Lord's blessing of goodness, kindness, gentleness, and love being poured into our empty vessels. We become healthy because He is healthy... we become beautiful because He is beautiful...we become loving because He is love. ᔧ

LORD,

Thank You that everything about You is good, pure, and right. Thank You that Your way is true and righteous altogether. I want to follow You in truth and walk on the straight paths You have for my feet. I rejoice in Your cleansing, Your renewing, and Your healing presence within me. ❧

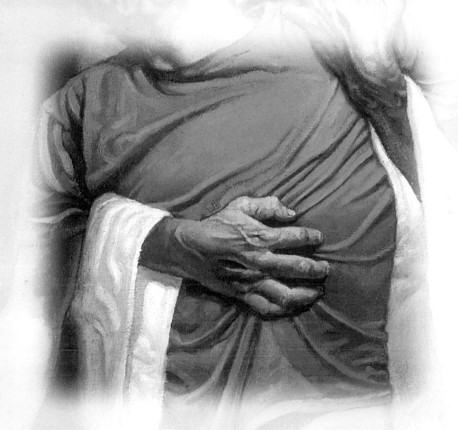

CHANGE

*T*herefore if any man is in Christ, he is a new creature; the old things passed

away; behold, new things have come. 'Moreover, I will give you a new

heart and put a new spirit within you; and I will remove the heart of

stone from your flesh and give you a heart of flesh.' So that Christ may

dwell in your hearts through faith; and that you, being rooted and

grounded in love, may be able to comprehend with all the saints what

is the breadth and length and height and depth, and to know the love

of Christ which surpasses knowledge, that you may be filled up to all

the fulness of God.

II Corinthians 5:17 ❧ Ezekiel 36:26 ❧ Ephesians 3:17-19

The wounded hand of Jesus over the man's heart upholds him and reveals God's desire to change all hearts by the power of His love.

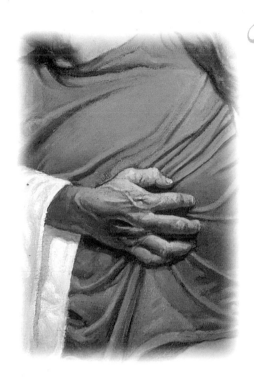

When we come to Jesus Christ in our brokenness and need, He receives us as we are, but because He loves us He doesn't want to leave us that way. He has come to make all things new.

His path is a path of hope. His way is a way of change. He doesn't just forgive us, He cleanses us...He doesn't just receive us, He indwells us...He doesn't just justify us, He gives us a new heart. He causes us to hate the things we used to love and love the things we used to hate. He changes us from the inside out. His Holy Spirit comes to live within us, we are born of God, and His love is shed abroad in our hearts. We begin to think as He thinks and feel as He feels. He removes our stone hearts— cold, hard, and unbending and gives us a heart of flesh—warm, tender, and yielding. He gives us a heart to love Him, adore Him, and enjoy Him. A heart of devotion...a heart of communion... a heart of compassion.

Through this change we become clay in the Potter's hands, formed into vessels as He wills... vessels that are honorable in the Master's house, fit for His use...vessels that are filled with the treasure of Jesus Christ.

LORD,

Only You have the power to change me and the wisdom to know what is best for me. I am safe in Your keeping and secure in the knowledge that I am a new creation in Christ. Mold me and shape me into a vessel that will be pleasing in Your sight, then fill my heart with the love of Jesus Christ.

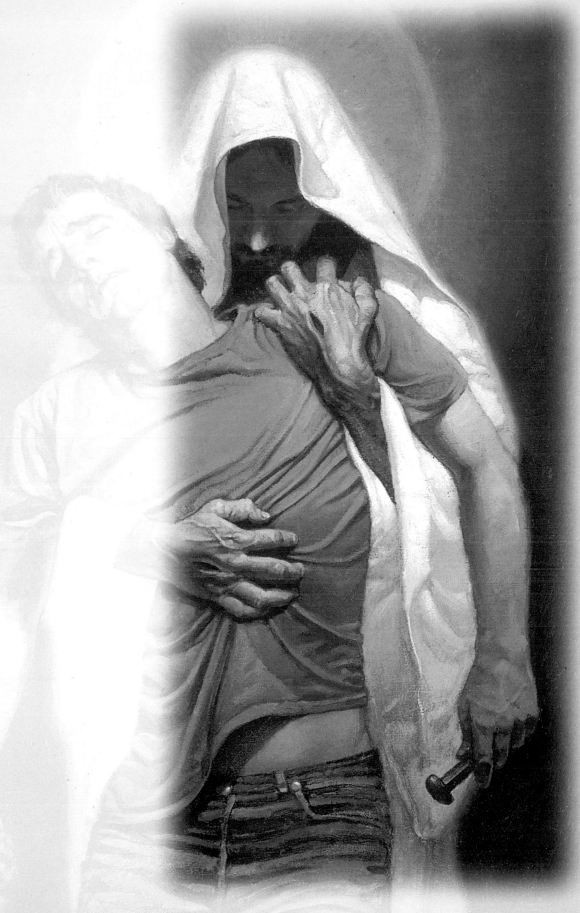

RIGHTEOUSNESS

*A*s sin reigned in death, even so grace might reign through righteousness

to eternal life through Jesus Christ our Lord. He made Him who knew

no sin to be sin on our behalf, that we might become the righteousness

of God in Him. He Himself bore our sins in His body on the cross, that

we might die to sin and live to righteousness; for by His wounds you

were healed. That I may gain Christ and may be found in Him, not

having a righteousness of my own derived from the Law, but that

which is through faith in Christ, the righteousness which comes from

God on the basis of faith. I will rejoice greatly in the Lord, my soul will

exult in my God; for He has clothed me with garments of salvation, He

has wrapped me with a robe of righteousness, as a bridegroom decks

himself with a garland, and as a bride adorns herself with her jewels.

Romans 5:21 � II Corinthians 5:21 ⋞ I Peter 2:24 ⋞ Philippians 3:9 ⋞ Isaiah 61:10

The white robe that Jesus is wearing speaks to us of His righteousness. It is the garment with which we must all be clothed.

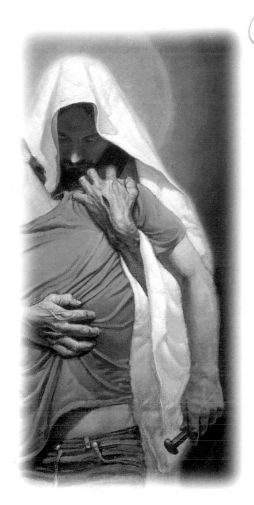

There is a story in the Bible that tells us about a great wedding feast. Everyone at the feast needed to be clothed in the proper wedding garments. A man was at the feast without the proper garment on, and when he was discovered, he was sent away from the celebration.

This story reminds us of the importance of being clothed with the right garment—the clean, pure white robe of the righteousness of Jesus Christ. Our own righteousness is like wearing filthy garments in God's sight. No one will be saved by his or her good works. No one is righteous. We please God not by trying to be better but by receiving the righteousness which is ours by faith in His Son.

We can never scrub out the stains in our soiled garments by becoming more religious; we can never swap our tattered garments for new ones by making resolutions, or by trying to start over; we can never improve our garment's condition by joining others whose garments seem to be whiter than ours. It is His purity that washes us...His goodness that clothes us...His glory that covers us. We are made and declared righteous by the righteousness of Jesus Christ alone. ॐ

LORD,

*I*t is only by faith that I can begin
to comprehend how You could
take someone like me and declare
me righteous. Your mercy overwhelms
me; Your grace is beyond anything
I have ever known. Thank You for
clothing me with the righteousness
of Jesus Christ and freeing me from
the bondage of trying to earn my
way to You. ॐ

JUSTIFICATION

*H*e is the radiance of His glory and the exact representation of His nature,

and upholds all things by the word of His power. When He had made

purification of sins, He sat down at the right hand of the Majesty on

high. And they sang a new song, saying, 'Worthy art Thou to take the

book, and to break its seals; for Thou wast slain, and didst purchase

for God with Thy blood men from every tribe and tongue and people

and nation.' He saved us, not on the basis of deeds which we have

done in righteousness, but according to His mercy, by the washing of

regeneration and renewing by the Holy Spirit. In whom we have

redemption, the forgiveness of sins. Much more then, having now

been justified by His blood, we shall be saved from the wrath of God

through Him.

Hebrews 1:3 ๛ Revelation 5:9 ๛ Titus 3:5 ๛ Colossians 1:14 ๛ Romans 5:9

The blood that flows from Jesus' feet signifies the washing away of our sin and our justification before God.

The shed blood of Jesus Christ has accomplished our justification before God—God receiving us just as though we had never sinned. Because of Christ's shed blood, God can look at our lives no matter how dark, how sinful, or how unclean they may have been and declare us guilt-free! In justification our debts are not only canceled, they are wiped clean; our sins are not only forgiven, they are remembered against us no more.

Justification is a legal term. If we are brought before a judge to be tried for a crime and proven innocent, we have been justified. If we are proven guilty, we cannot be justified, and we must pay the penalty for our crime. The only way we could ever be declared justified once we've been proven guilty is to have someone else meet the full demands of the law by taking our punishment for us. Christ's blood has justified us because we were guilty, and He took our judgment for us. He is the spotless lamb offered up for the transgressor...the obedient Son taking the place of the rebellious child...the caring Creator yielding His life for His fallen creation. ✣

LORD,

I praise You that I can stand before
You guilt-free. What a great salvation
You have brought me. You didn't just pity
me, You came to take every judgment
I deserved; You haven't just forgiven me,
You have regarded my sin as though
it had never happened. You are my
wonderful Saviour, and I am grateful! ✍

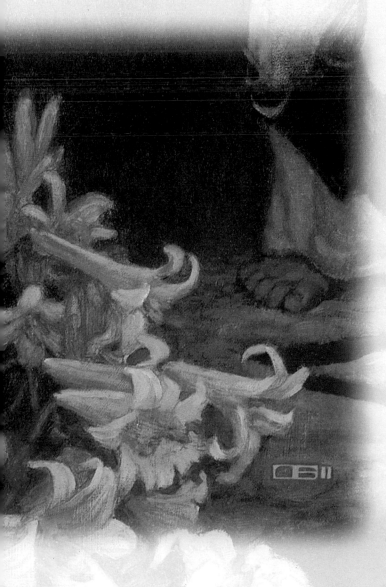

WORSHIP

I am the rose of Sharon, the lily of the valleys. Come, let us worship and

bow down; let us kneel before the Lord our Maker. Worship the Lord

in holy attire; tremble before Him, all the earth. Then the King will

desire your beauty; because He is your Lord, bow down to Him. The

twenty-four elders will fall down before Him who sits on the throne,

and will worship Him who lives forever and ever, and will cast their

crowns before the throne, saying, 'Worthy art Thou, our Lord and our

God, to receive glory and honor and power; for Thou didst create all

things, and because of Thy will they existed, and were created.' And

they sang a new song, saying, 'Worthy art Thou to take the book, and

to break its seals; for Thou wast slain, and didst purchase for God with

Thy blood men from every tribe and tongue and people and nation.'

Song of Solomon 2:1 ❧ Psalm 95:6 ❧ Psalm 96:9 ❧ Psalm 45:11 ❧ Revelation 4:10, 11 ❧ Revelation 5:9

The lilies in Forgiven *remind us of the Lord's beauty and our worship and adoration of Him, the Lily of the Valley and the Rose of Sharon.*

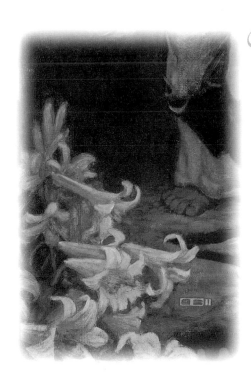

What does Jesus look like? There are many paintings that show an artist's interpretation of what Jesus looked like. However, when the Bible tells us what Jesus looked like, it doesn't describe His specific physical characteristics. Isaiah 53 tells us "He has no stately form or majesty that we should look upon Him, nor appearance that we should be attracted to Him."

The Bible describes Jesus by telling us about His character and His actions. He went about doing good. He had compassion on the multitudes, seeing them as sheep in need of a shepherd. He healed the sick and freed the oppressed. He comforted those who mourned and touched the lives of those who were untouchable. Jesus looked like love...He looked like joy...He looked like the fruit of the Spirit. In His face the glory of God was reflected, through His eyes the heart of the Father was seen, from His smile the favor of God was manifest. Jesus looked like purity and holiness. He looked like everything good and right. The closer we draw to Jesus and learn His heart, the more beauty we see. Like the rose, it is in closeness and intimacy that its fragrance is the strongest and sweetest. As we draw close to Him in worship, we will see His beauty clearly, and as we delight ourselves in His presence, the fragrance of the Lord will intoxicate our souls.

LORD,

You are beautiful, and I honor You. I want to draw close to You and learn Your mind. I want to walk close to You and understand Your ways. I want to be close to You and know Your heart. Open up my capacity to comprehend the height, depth, length, and width of Your vast love. Each day I want to gaze upon Your face, see Your glory, and become a worshiper of You.

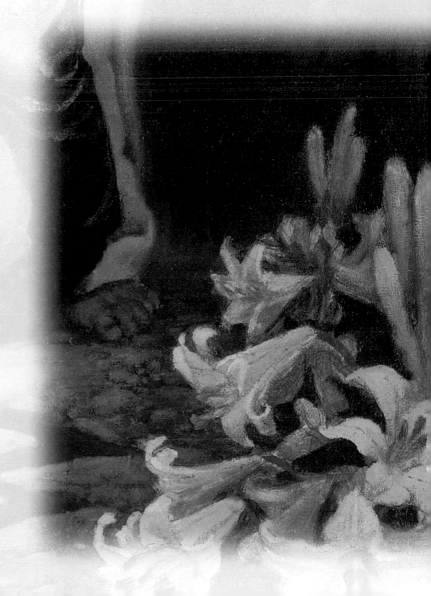

GROWTH

I will be like the dew to Israel; He will blossom like the lily, and he will take

root like the cedars of Lebanon. 'I am the vine, you are the branches;

he who abides in Me, and I in him, he bears much fruit; for apart from

Me you can do nothing.' But the fruit of the Spirit is love, joy, peace,

patience, kindness, goodness, faithfulness, gentleness, self-control;

against such things there is no law. So that you may walk in a manner

worthy of the Lord, to please Him in all respects, bearing fruit in every

good work and increasing in the knowledge of God. Grow in the grace

and knowledge of our Lord and Saviour Jesus Christ. To Him be the

glory, both now and to the day of eternity.

Hosea 14:5 ❧ John 15:5 ❧ Galatians 5:22, 23 ❧ Colossians 1:10 ❧ II Peter 3:18

The lilies also represent our personal growth in the Lord.
Because He is alive in us, His life will produce fruit for His glory.

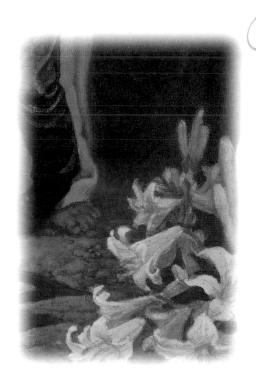

The wonder of a seed is that it produces life after it has been planted in the ground and dies. The message of the Gospel is that life has come out of death. Jesus died that we might live. He was buried and rose from the dead that we might be raised to newness of life. When we come to Jesus Christ by faith, turn from our personal darkness of sin, and receive His grace and forgiveness, He cleanses us and comes to live within our hearts. We are born again of His Spirit.

The resurrection life of Jesus Christ enters us and we are changed. He plants within us the seeds of His kingdom, and through our faith and obedience the new life begins to grow. The Christian life is not produced by studying how Jesus lived and then trying to copy Him. It is not a script we study and attempt to act out. It is not like taking plastic fruit and attaching it to our garments to make us look like fruit trees. It is a real life...a whole life...a fulfilling life...a worthy life...a meaningful life...it is His life lived out through us. It is His beauty that others see, it is His fragrance that others are drawn to, it is His fruit that others will partake of and be fed. He is your life. He is all there is...all that is worth knowing...and all that really matters.

LORD,

*T*hank You for the good work that You have begun in me. Thank You that I am alive in You because of the life of the Holy Spirit within me. I want to rest in Your love and abide in Your presence. I want to grow in faith and see Your life formed in me. Feed me through Your word and water the seeds planted in my heart. Make me a fruitful branch that can feed others and daily glorify You.

*F*or He delivered us from the domain of darkness,

and transferred us to the kingdom of His beloved Son,

in whom we have redemption,

the forgiveness of sins.

Colossians 1:13, 14

HOW TO BE FORGIVEN

One of the greatest joys that the heart can ever experience is forgiveness. Nothing else can set you free from the guilt of the past and place your feet on a new path of hope. Forgiveness comes to you as a free gift from God. You cannot earn it in any way; you can only receive it. Forgiveness is not based on what you have done, how good you have tried to be, or how sincere you have been. Your forgiveness is based on the sacrifice that Jesus Christ has made for your sins. It is by His blood alone that you can be made clean.

Your forgiveness is only a prayer away. Turn your heart to God, confess and forsake your sins, and ask Him to cleanse and forgive you. His Word says that He will do it by His grace and mercy. He will wash you and make you clean. As you pray, ask Jesus Christ to come into your heart and live in you. He will be your Lord and Saviour. His life will make you new inside.

Ask Him today and start all your tomorrows with the joy of being forgiven.

About the Author

ROY LESSIN is a co-founder of DaySpring Greeting Cards and has been the senior writer for the past 25 years. He is a graduate of Bethany School of Missions, where he received his ordination. Before writing for DaySpring, he was director of Christian education in Oakland, California, and served as a missionary in Mexico and Puerto Rico. Lessin has written several books for children, two books for Christian parents on child training, and four devotional books.

About the Artist

THOMAS BLACKSHEAR II's highly awarded work has appeared in the *Society of Illustrators Annuals* and *Outstanding American Illustrators Today*, Volume 2. Some of his clients have included Disney Pictures, Coca-Cola, Jim Henson Studios, *National Geographic*, and Universal Studios. His 28 portraits of famous black Americans, commissioned by the U.S. Postal Service, were published in the 1992 commemorative book *I Have A Dream*, and 19 of the paintings have been exhibited at the Smithsonian Institute.

Blackshear studied at the American Academy of Art in Chicago on a full grant. He left his highly awarded secular career in illustration to devote his life to God's purposes and painting, as he says, "just for the joy of it." Soon God brought Blackshear to *The MasterPeace Collection*, a division of DaySpring Cards, and *Forgiven* was commissioned in 1992.